D0952723

reasons
to be
happy

sandy gingras

**Andrews McMeel
Publishing, LLC**

Kansas City · Sydney · London

09 10 11 12 13 WKT 10 9 8 7 6 5 4 3 2

ISBN-13: 978-0-7407-7877-3
ISBN-10: 0-7407-7877-3

Library of Congress Control Number: 2009922410

www.how-to-live.com
www.andrewsmcmeel.com

The world is so full
of a number of things,
I'm sure we should all be
as happy as kings.

Robert Louis Stevenson

You probably opened this book because you're looking for happiness in a hard time (as are we all). I wish I had a map to steer us out of heartache, a winning lottery ticket on pg. 12, a cure for cancer, a beam-us-up-Scotty-out-of-this-mess-we're-in machine. I wish it were easy.

But all I have are moments (and moments are the hardest of things). Slippery. Intangible.

Fleeting. If I tell you though that moments ARE a kind of map, a kind of wealth, a kind of cure, will you believe me? I can tell you that they've helped me through the hardest times...

There are reasons to be happy in... the shape of that cloud... the way she said what she said... a nudge of breeze... Find reasons here and there. Look for them everywhere. Add them up until, at the end of the day, there's a pile of reasons

for you
to jump in!

So...start anywhere...

nothing is
too small

I hope, together, we gather a lot of reasons to be happy.

Because the world
could use them.

the clean-as-a-whistle
feeling of the world
when the sun pops out
after a rainstorm

the float·y
dress with
the embroidered
roses
that makes
you feel
like a
princess

an old-fashioned
browsy bookstore

welcome

339

the promise of seed packets

SNOW PEA

PEPPER

SNAP DRAGON

FOXGLOVE

POPPY

ZINNIA

CARROT

TURNIP

TOMATO

summer nights

- catching fireflies on the lawn
- cicadas and crickets wheeking and chirping and buzzing in chorus
- swaying on the porch swing
- riding a bike clickety-swish down a long quiet street, a flashlight in your basket to light your way
- flashlight tag
- the damp delerious night air

a quiet spot to call
your own

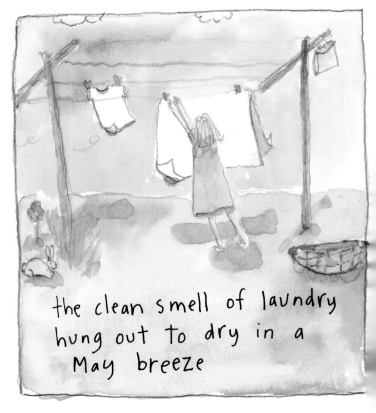

the clean smell of laundry
hung out to dry in a
May breeze

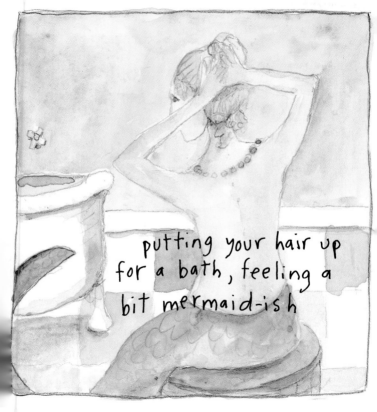

putting your hair up for a bath, feeling a bit mermaid-ish

hearing an old
song and remembering...

the scent of spring:
part leaf and rain, part
quiver and newness, a
measure of relief, one of
joy, some let-loose-from-
dormancy and if-pale-green-
had-a-scent, a bit of bud
and push, some grow,
some pollen, some sunshine,
and some bee...

the delicacy of a
butterfly balancing
on a peony

funny little foods that make you smile just thinking of them

- Froot Loops
- jujubes
- goldfish
- petite peas
- m & m's
- alphabet noodles in soup
- minimarshmallows
- rainbow sprinkles

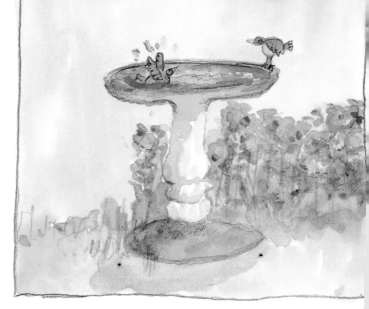
birds splish-splashing
around in the birdbath

phrase:

her head is in
the clouds

kindness

that small town
feeling

high five

an old wagon
filled with herbs

lending a book
that you
love

the magical whir
of a hummingbird

Smiley smells

- chocolate chip cookies baking
- butter melting
- roasted garlic
- barbecue
- mountain air
- vine-picked tomatoes
- pine-scented candles
- bread baking
- a new-mown lawn
- lemon verbena soap

Just-washed
blueberries
in a colander

soft glowy candles on the picnic table

my dear ___

I can only tell you that you are the woman I get you as the morning you are the reason you and everything all of this you are everything

love letters

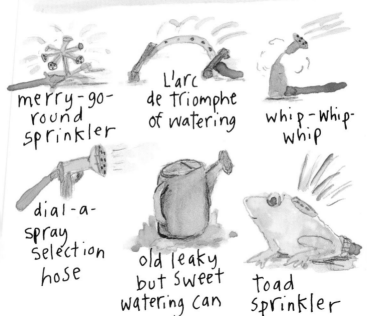

the many ways to water
the garden

merry-go-
round
sprinkler

L'arc
de triomphe
of watering

whip-whip-
whip

dial-a-
spray
selection
hose

old leaky
but sweet
watering can

toad
sprinkler

droopy-headed sunflowers

fresh picked

the roadside farm stand

early morning moments

- hearing the newspaper delivered (thump)
- when you remember your dream
- padding quietly around before anyone else gets up
- the way the dark gets pink just before dawn
- the coffee beginning to perk
- the dog waiting with the leash...

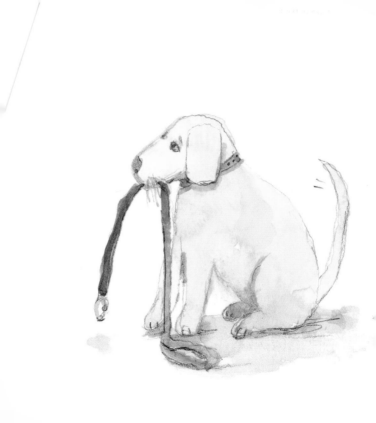

when it's handmade

gentleness

when he calls you
just to hear the
sound of your voice

jeans worn in
just right

the road home

One more Indian summer day

getting the window
seat

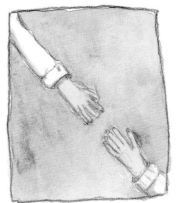

a helping hand

noodles

• ziti • ditalini • elbow macaroni
rigatoni • shells • wagon wheels
• linguini • spaghetti • angel hair

doorbell rings

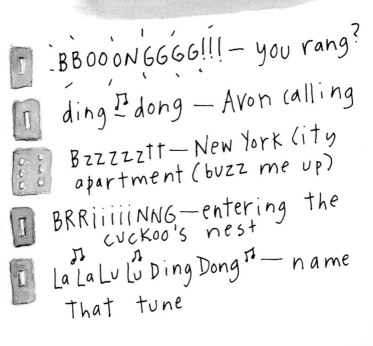

BBOOONGGGG!!! — you rang?

ding ♫ dong — Avon calling

BZZZZZtt — New York City
apartment (buzz me up)

BRRiiiiiNNG — entering the
cuckoo's nest

♫ La La Lu Lu Ding Dong ♫ — name
that tune

watching him shave

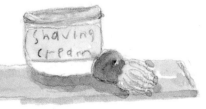

Lincoln Logs: something about the easy way they fit together that makes you feel like you can make anything

the first step (aaah) into a hot shower

politeness

Kid Sandwiches

- mayo on white bread
- fried bologna
- four Oreos on Wonder Bread
- a butter sandwich, no crusts
- fluffernutter, banana, and peanut butter on raisin bread
- a ketchup sandwich
- PB & J

bon appétit!

a lively curiosity

puppies in a basket

mini-hot dogs at
a fancy party

fall afternoons

the slant of sun against orange
 leaves

a big chunky cable-knit sweater

apple cider

concord grapes in a
wooden basket

the last leggy zinnias

"Jack Frost was here!"

the words: brisk, bracing,
crisp, and nippy

Sifting flour: how flour can get even more floury

Aha!

- a good idea popping out of nowhere
- remembering!
- the last piece of the puzzle
- filling in the blank
- "By George, I think I've got it!"
- a moment of truth arriving
- a creative spark

a bouquet of kindling
in a galvanized bucket

Silly hats

giant
pom-pom

stocking

Santa

Russian

muffs

Peruvian
hippie

artist

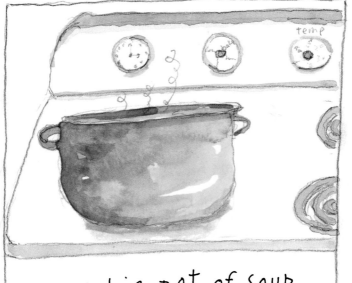

a big pot of soup
simmering on the
stove

winter moments

everyone going to the grocery store to stock up when a storm is predicted

red mittens and alpine sweaters

the big green blob of a blizzard moving toward you on the weather map

crooked snowmen

"Is it cold enough for you?"

coziness

the scent and snap of a wood fire

fuzzy slippers

making a snow
angel

a heart-shaped pizza
on Valentine's Day

still holding
hands

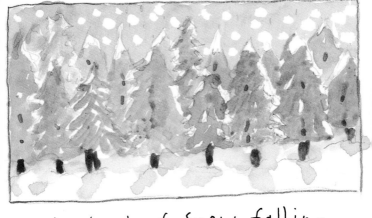

the hush of snow falling
in the pine forest